Horsespirations

SWEET & SIMPLE TRUTHS FROM OUR EQUINE FRIENDS

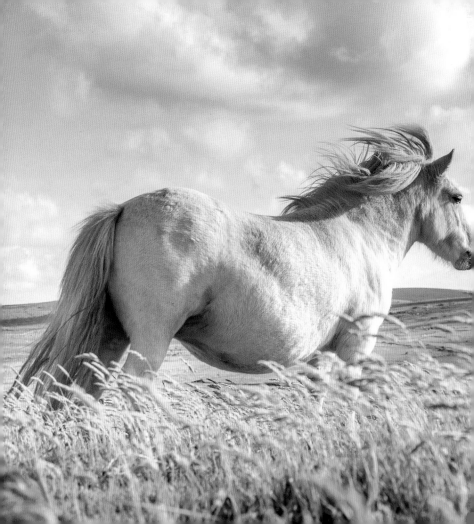

Horsespirations

SWEET & SIMPLE TRUTHS FROM OUR EQUINE FRIENDS

WILLOW CREEK PRESS

Published by Willow Creek Press, Inc.
P.O. Box 147, Minocqua, Wisconsin 54548

Printed in China

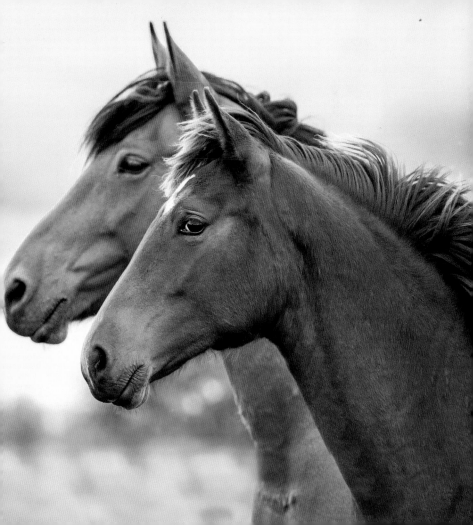

ONE DAY OR

Day One

YOU DECIDE

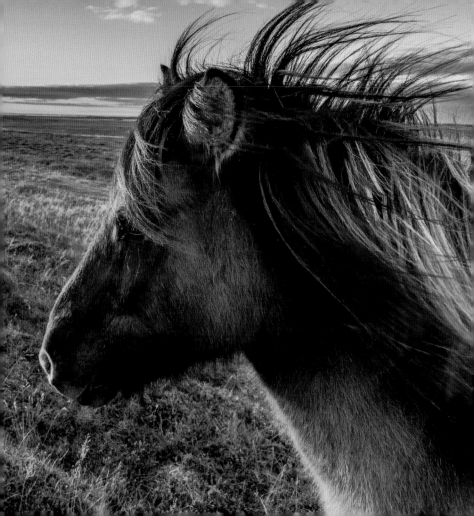

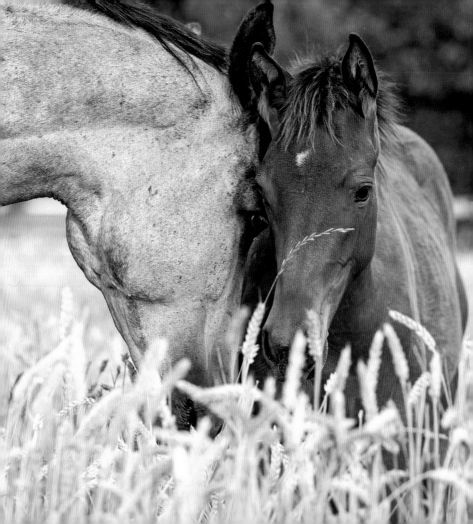

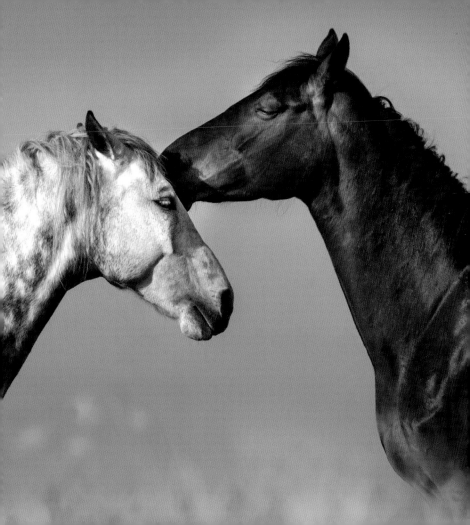

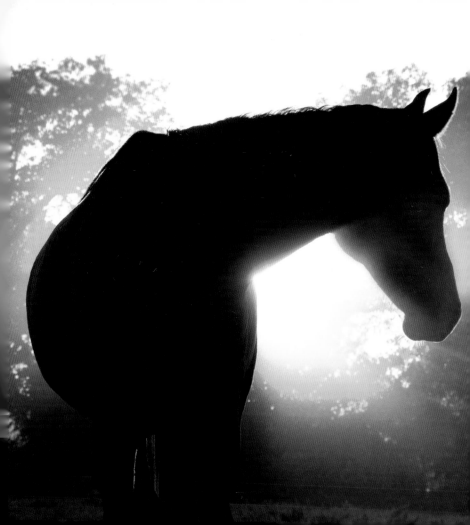

KEEP YOUR FACE TO THE

Sunshine

AND YOU CANNOT SEE THE SHADOWS

Bloom
WHERE YOU ARE
Planted

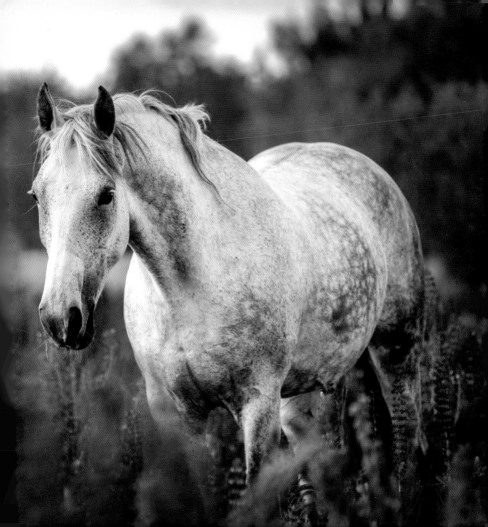

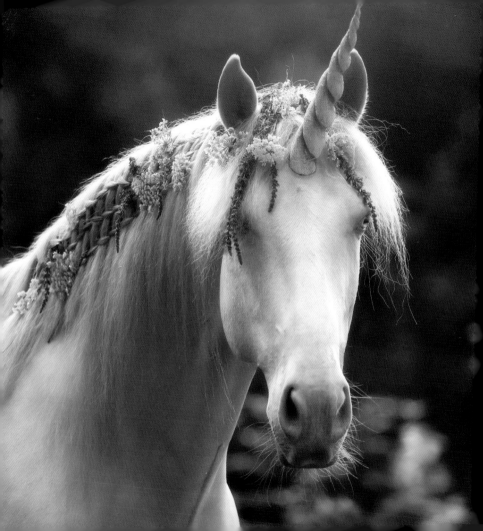

IMAGINATION Will Take YOU EVERYWHERE

FOLLOW YOUR

Passion

AND SUCCESS WILL FOLLOW YOU

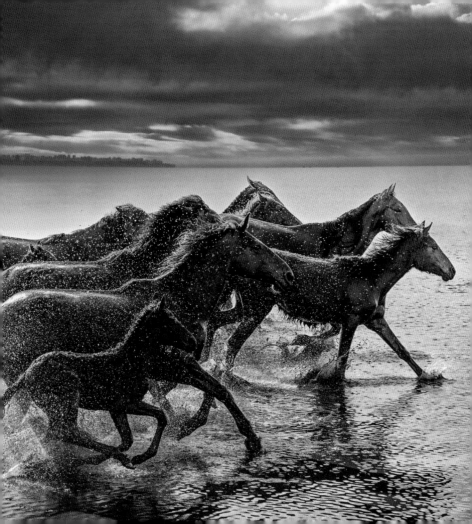

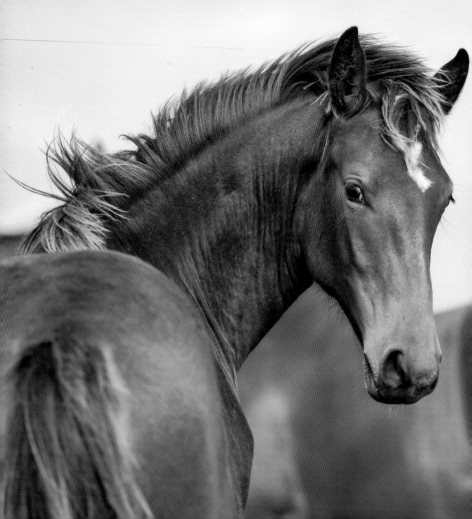

DON'T

Stumble

OVER SOMETHING

Behind

YOU

DREAM Bigger THAN YOU CAN Doubt

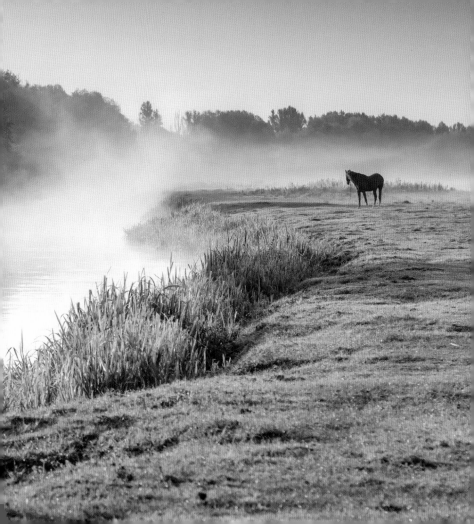

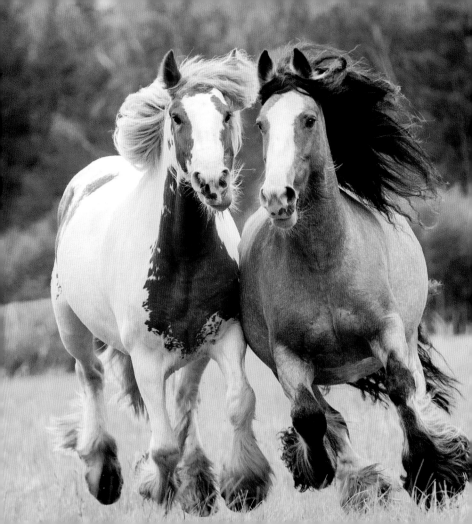

IT TAKES A

Long Time

TO GROW AN OLD FRIEND

Everything you want is on the Other Side of Fear

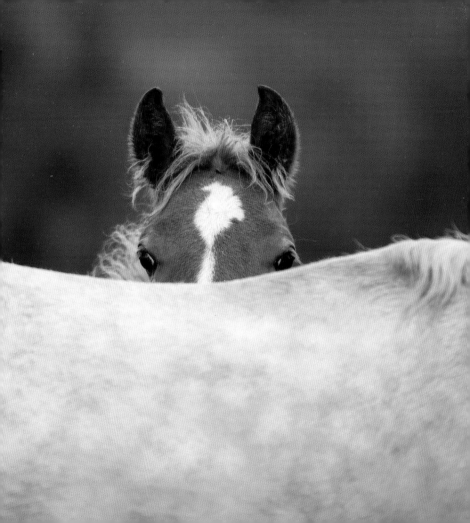

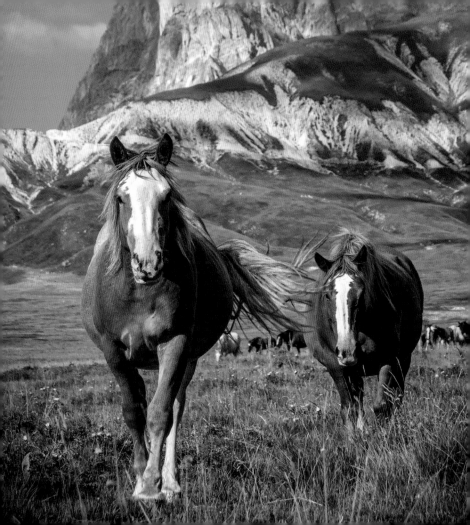

Difficult

ROADS LEAD TO

Beautiful

DESTINATIONS

ONLY A LIFE LIVED FOR *Others* IS A LIFE WORTHWHILE

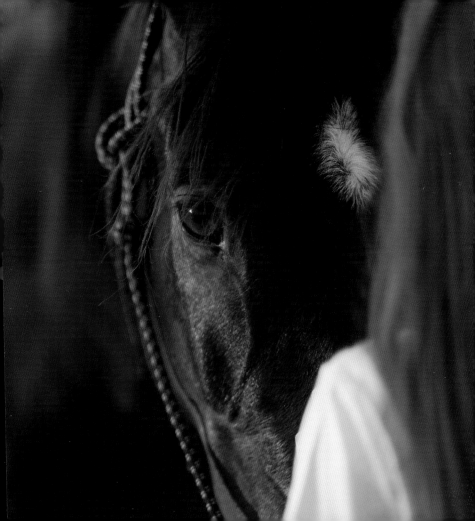

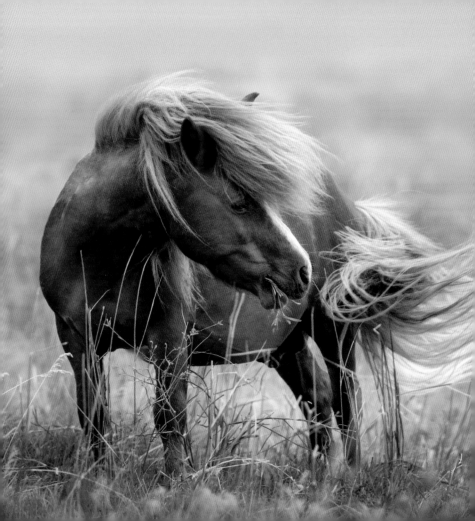

TIME YOU ENJOY

Wasting

IS NOT WASTED TIME

Limits

ARE FOR

Those

WHO NEED THEM

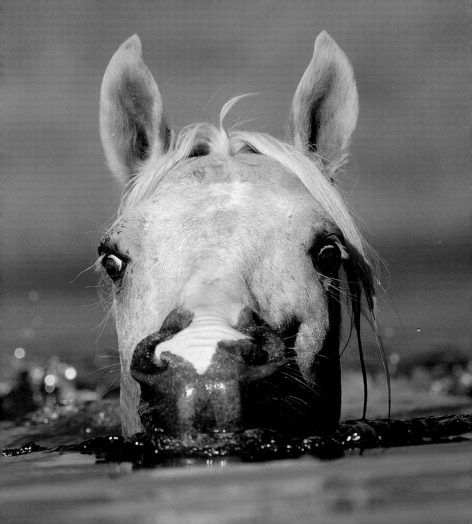

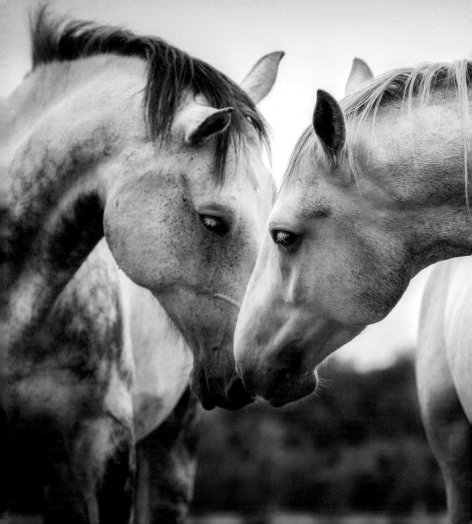

KNOWLEDGE Speaks WISDOM Listens

THE BEST
View
COMES AFTER THE HARDEST
Climb

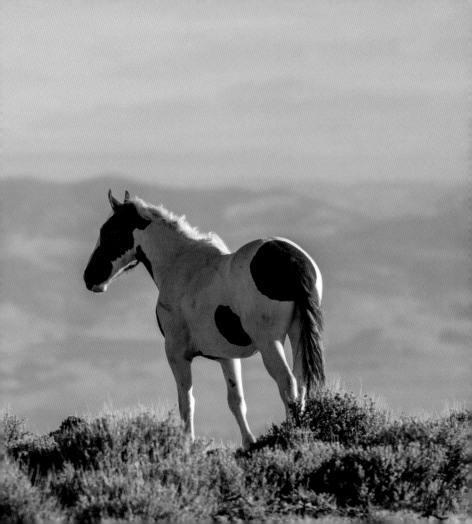

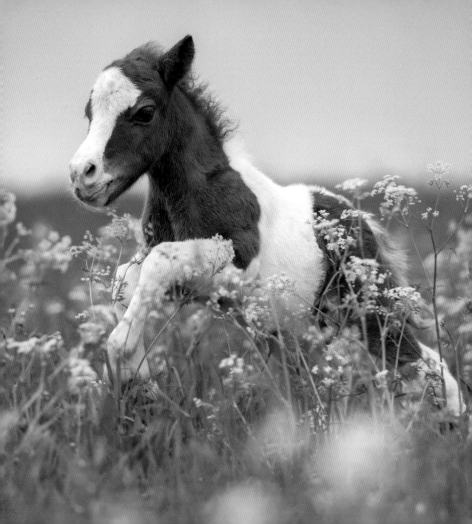

YOU ARE MORE

Capable

THAN YOU KNOW

A SWEET Friendship REFRESHES THE SOUL

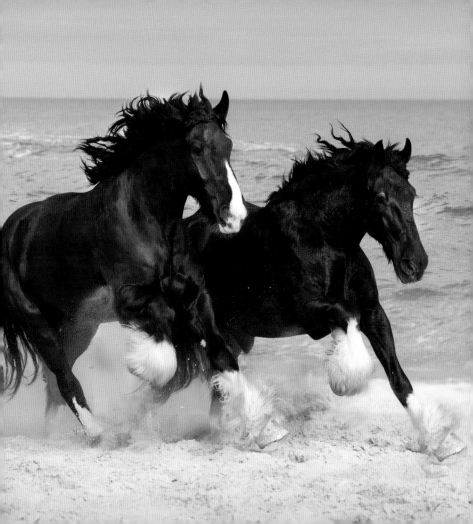

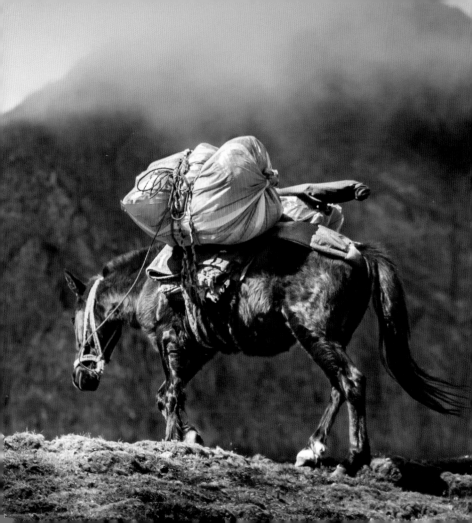

YOU CAN DO

Anything

BUT NOT EVERYTHING

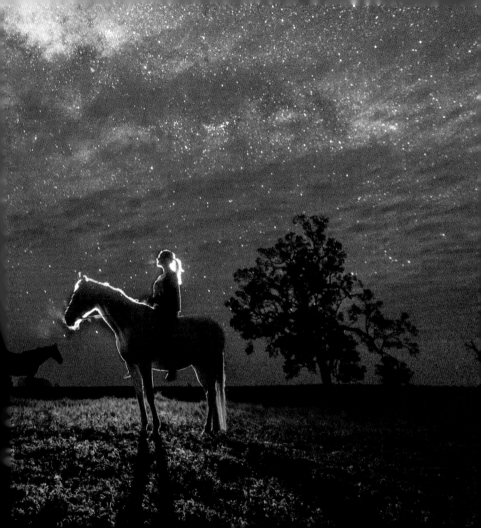

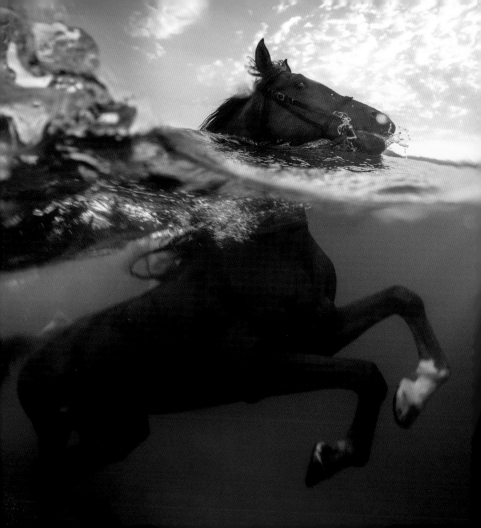

IT'S THE *Will* NOT THE *Skill*

Kindness COSTS Nothing

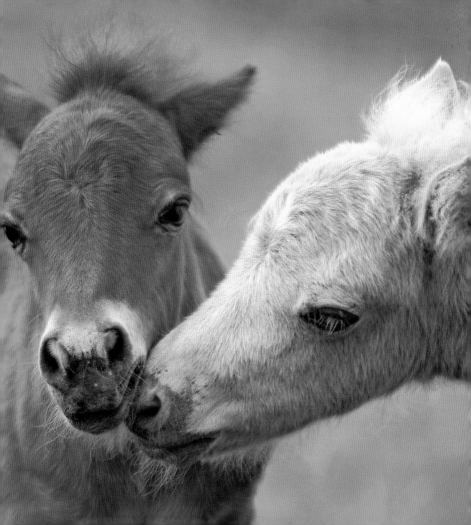

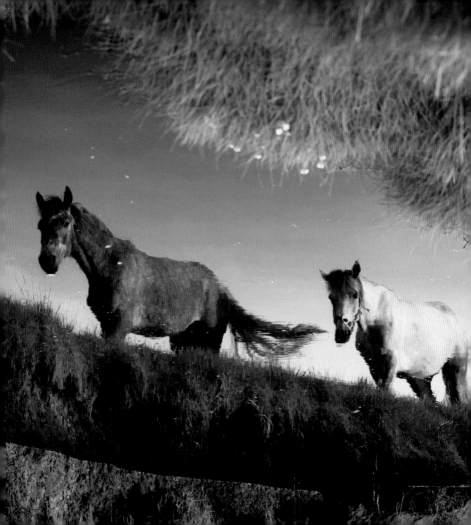

YOU MIRROR WHAT THE

World

MIRRORS TO YOU

ALONE WE CAN DO SO LITTLE

Together

WE CAN DO SO MUCH

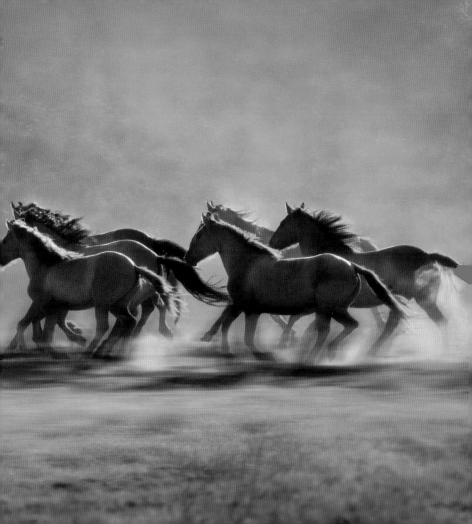

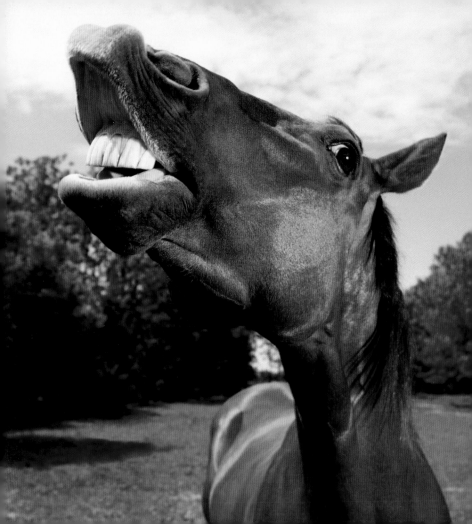

GREET THE

People

YOU LOVE WITH A

Smile

THE
Struggle
IS ONLY PART OF THE
Story

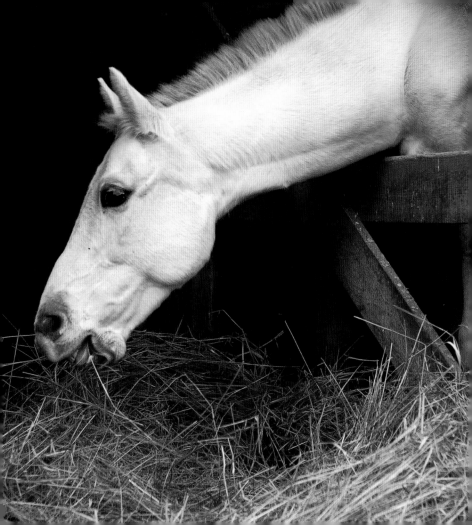

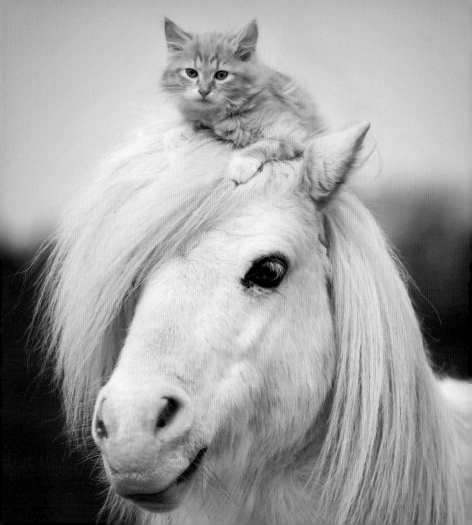

Love FOR All
HATRED FOR NONE

TRY TO BE A *Rainbow* IN SOMEONE'S *Cloud*

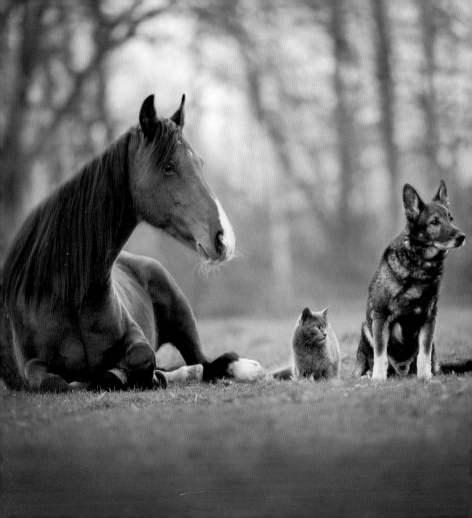

BEING Unique IS BETTER THAN BEING Perfect

Obstacles

DO NOT BLOCK THE

Path

THEY ARE THE PATH

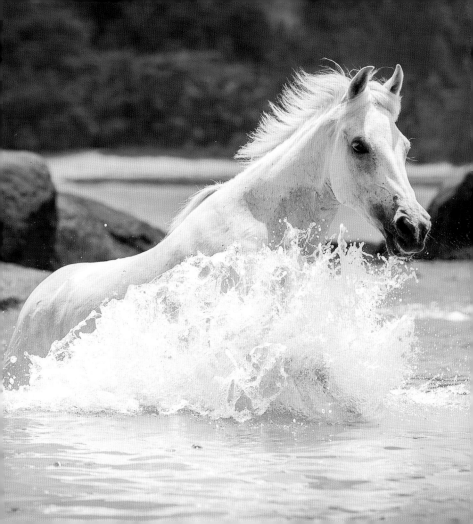

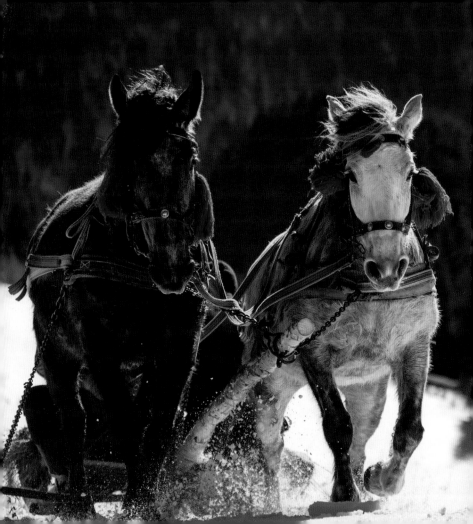

ALL THINGS WORK

Together

FOR GOOD

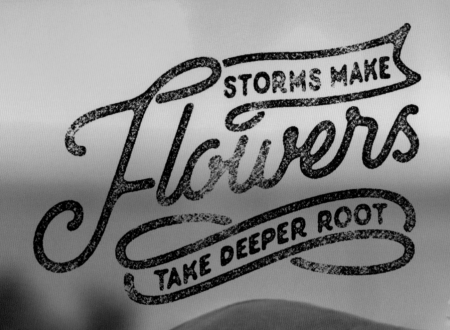

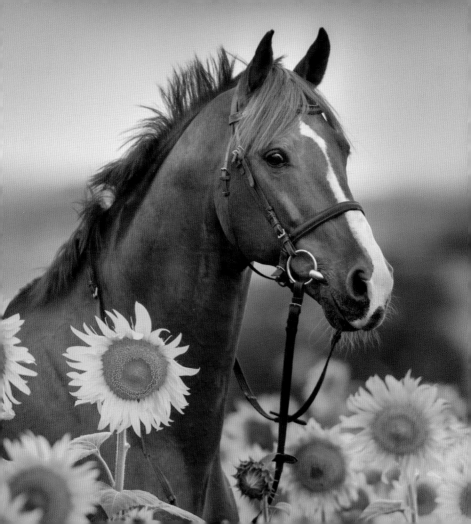

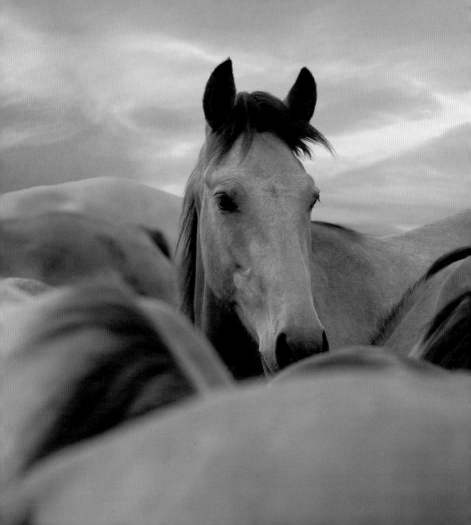

Do Less

WITH MORE

Focus

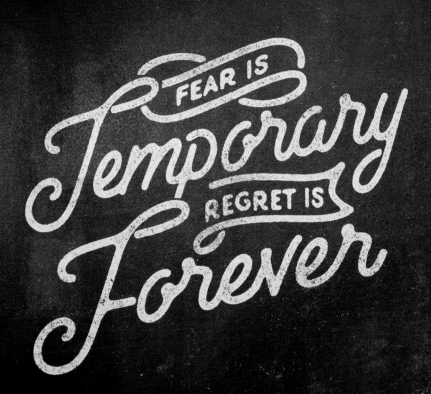

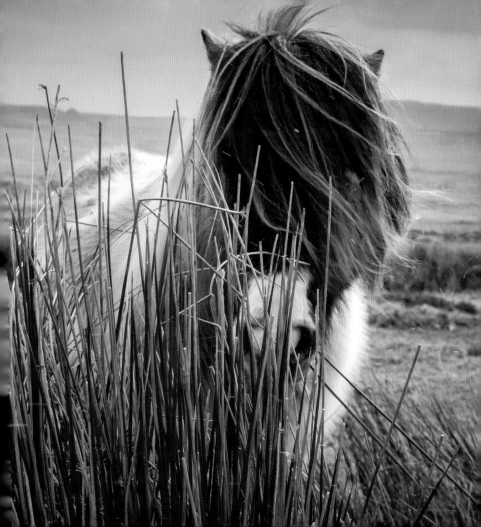

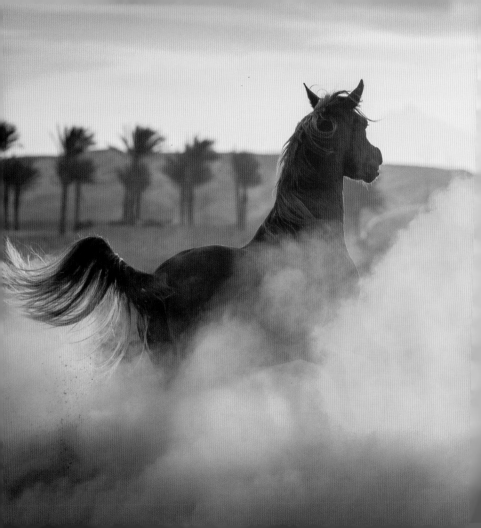

SOME DAYS YOU JUST HAVE TO

Create

YOUR OWN SUNSHINE

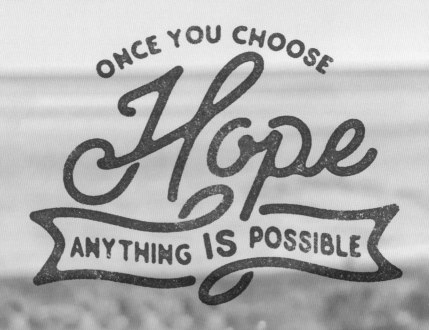

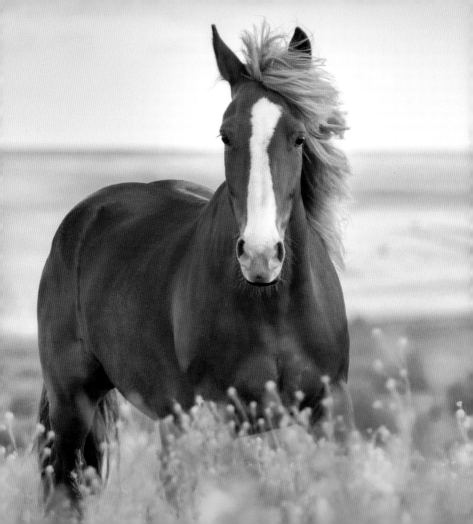

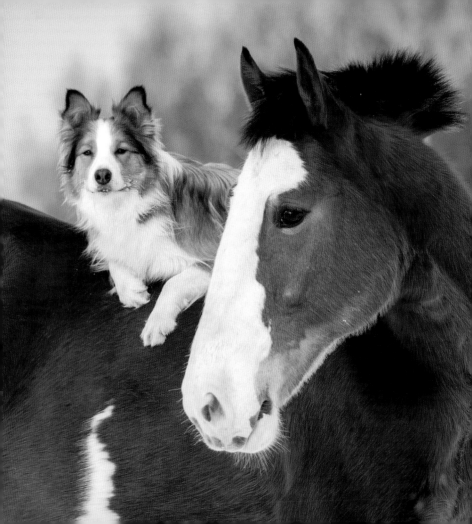

IT TAKES

Strength

TO BE GENTLE AND KIND

WHEN LIFE GETS

Blurry

ADJUST YOUR

Focus

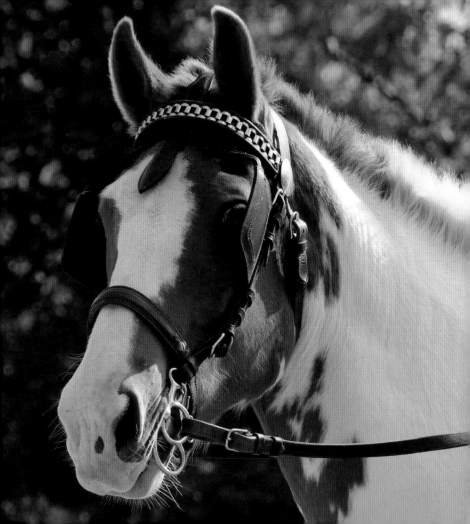

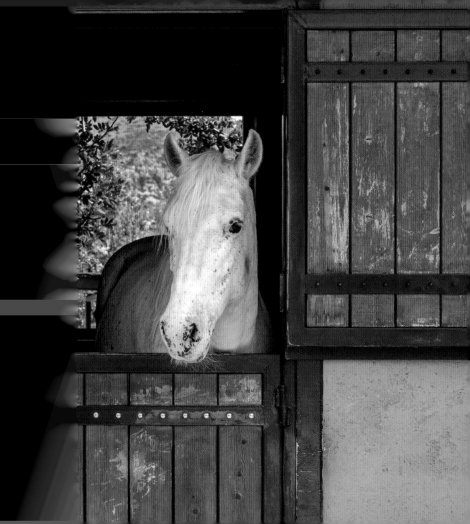

WHEN ONE DOOR

Closes

ANOTHER ONE

Opens

DO NOT
Regret
THE PAST
Learn
FROM IT

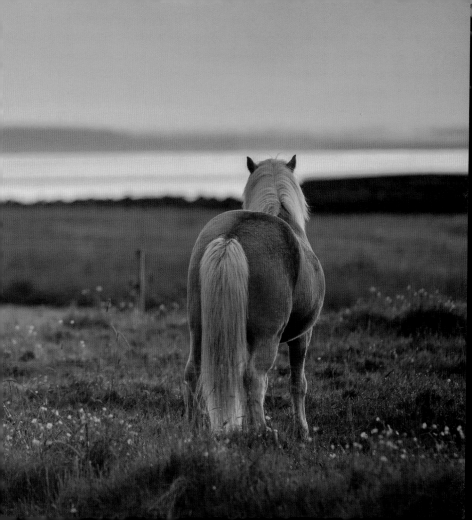

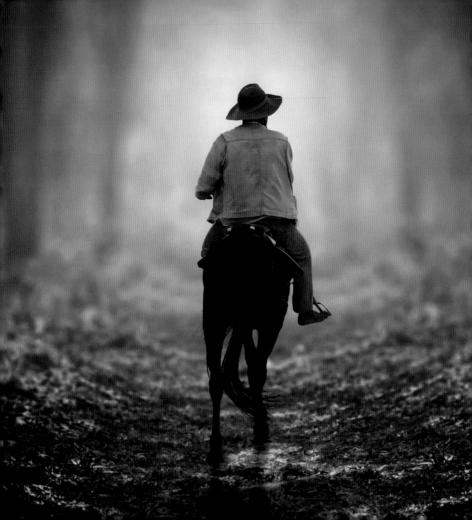

Embrace
THE
Journey

Failure is success in Progress

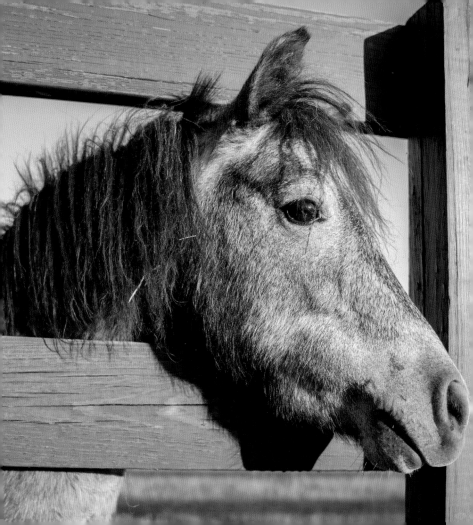

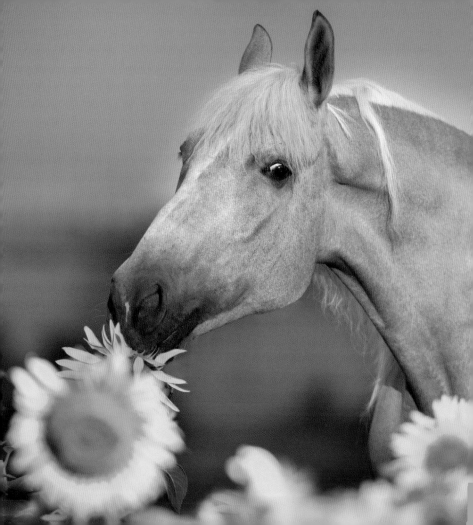

THERE ARE ALWAYS

Flowers

FOR THOSE WHO WANT TO SEE THEM

Sometimes THE ONLY WAY OUT IS Through

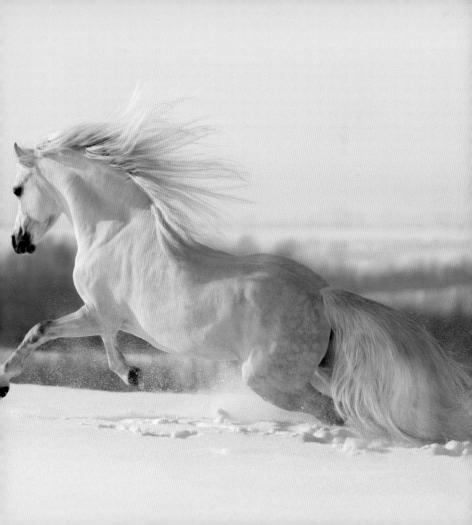